SEASIDE POLAROIDS

JON NICHOLSON

With a foreword by
Joseph Galliano

Prestel
Munich · London · New York

Foreword

Joseph Galliano

'What we crave, and what is so popular now, are those apps on phones that make our pictures look like these. Well, this is the real thing, done with an obsolete camera and a bag of out-of-date film. Smashing.'

Jon Nicholson

The British seaside might seem an unlikely subject for Jon Nicholson. He is a photographer best known for intimate yet testosterone-driven sports coverage, in particular of Formula 1 racing, and also as a humane documentarian on subjects ranging from life and death in Africa to rodeo cowboys.

But everyone needs a holiday.

Before Nicholson went to work as the official behind-the-scenes photographer for the 2012 Olympics, he put down his SLR cameras, tripods and lenses, left his overstuffed gear bag in his garden shed/office, threw an old Polaroid camera in the car and took off on a tour of the coast. This wasn't just a physical tour, but one that played with time and memory.

It seems a lifetime ago, before digital cameras and smartphones became ubiquitous, when holidays and photography travelled hand in hand. For those of a certain age, it really wasn't a seaside holiday unless you captured some of the memories with an instantly gratifying Polaroid camera. There's something about the fuzzy focus and washed-out colours that evokes ice lollies, seagulls, breaks in the clouds and pebbles being lapped by the glittering grey sea.

Yet perhaps, for others, it's all about capturing the sleazier side of life: illicit lovers, sex games and grown-up fun. Either way, the photographs look like slightly faded memories.

Polaroid's first instant film cameras were launched in 1948, but it wasn't until 1965 before a really popular, cheaper model was launched (the aptly named Swinger), putting this type of photography on the mass market for the first time.

It was the perfect embodiment of accessible modernity and the timing couldn't have been better: Britain was rubbing its eyes and waking from post-war slumber, fashion was becoming more colourful and ephemeral, leisure time was on the up, pop culture was on the rise and the sexual revolution was fully underway. The peak of Swinger sales coincided with the golden age of the Great British Beach Holiday, which flourished before the explosion of bucket shops and budget airlines, with over 40 million people a year grabbing some rest and recuperation at the UK's coastal resorts during the early to mid-1970s.

By this time, the British seaside aesthetic had emerged as a curious, gaudy skin of Americana draped over Victorian bones and riddled with contradictions. Combining a sense of health and decadence, it was a place that brought families together as well as a magnet for dirty weekenders and would-be divorcees. But then, you might expect that of any frontier, somewhere that flotsam and jetsam gathers and gently churns.

It is almost as if the Polaroid was designed with this tension in mind, a paradoxical product that used cutting edge technology yet produced instantly nostalgic imagery. But with the unstoppable rise of digital, Polaroid Corporation ceased making its film stock in 2008. Whatever remained inevitably started going out of date. As the film's supply dwindled it became ever more unreliable and unstable. Batteries in the cartridges would start running down and quietly die.

In 2009, Nicholson was preparing for his wedding and browsing in Urban Outfitters when he came across a pack containing a Polaroid camera and some film stock, assembled by a group of analogue fetishists working under the moniker The Impossible Project. They had purchased the last Polaroid factory and were trying to bring instant photography back to life. 'Oh my God,' thought Nicholson. 'How wonderful. I must have this.'

He started taking snaps of friends with it when they dropped by his family home, which soon festooned his fridge. Then, he took it to the Seychelles on his honeymoon, intending to create tropical scenes à la David Hockney's giant Polaroid collages, inspired by the shimmering blue desertscape of Pearblossom Highway. On returning home, he began thinking about his out-of-date film stock and how it might lend itself to capturing the spirit of the British seaside.

March, of course, struck him as the ideal time to take this project on the road, and he circumnavigated the country, taking in Burnham-On-Sea, Blackpool, Brighton, Southend, Exmouth and Torquay, amongst others. He knew he had to ration film and vowed no retouching. This would be a one shot deal. His pictures would be at the mercy of the unpredictable weather and aging

chemicals. He intended to capture images with as few people in them as possible, but inevitably some became subjects. It was then that he truly realised how warmly people feel towards this technology. 'They are so nostalgic about it', he explains. 'You go out with this camera and they smile at you when you point it at them, unlike with my big work cameras. And they love being able to see pictures as they develop.'

The images have a wistful and sometimes brooding quality to them; they are at once idyllic and menacing. As with memory itself, they are recorded through a smoky haze: volleyball players unaware of the chalky bones of the burnt pier in Brighton which loom over them (see page 47); a rundown sign which reads 'Joyland', its very dilapidation standing as a counterpoint to its intended message (see page 31).

In some of these pictures you can almost feel the cold – and there's very little sadder than a chilly, windswept, out of season seaside town, abandoned now that the tourists have gone. Just look at the viewing telescope in Great Yarmouth, surveying the great empty turquoise wasteland. There's nothing to look at but the voyeurs themselves. Or take the monstrous *Blair Witch*-ness of the Blackpool Tower (see page 91) where huddled and threatening figures wait, like the land-scape and the tower itself, to eat you up.

But Nicholson's pictures also capture the other side of the coin: the impossibly optimistic retro-futurist architecture of the Worthing pier entrance showing us the way to "Amusements' (see page 53), or the British bloke with his feet up on the railings reading the paper against acres of azure West Sussex sky (see page 55). These pictures are all redolent with an unsentimental poetry.

Perhaps Nicholson sums it up best when he says, 'I want these pictures to evoke memories of childhood holidays by the seaside.'

Joseph Galliano is the editor of the *Dear Me: A Letter to My 16-Year-Old Self* series of books.

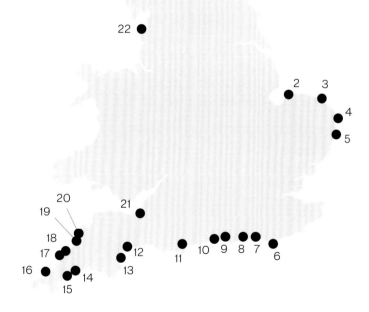

Introduction

Jon Nicholson

Starting out on this journey, I was full of fear because people don't really like to see cameras in public places anymore. Anyone pointing a camera around is looked upon as either a weirdo or a terrorist. However, the first thing I noticed while carrying my 1970s Polaroid camera was that people were smiling, wanting to talk to me about what I was doing. I was free to walk into places or take pictures without feeling out of place.

During my trip, a few people shared their own memories of encountering Polaroids when they were growing up. A man in Hunstanton still has a collection of pictures from when he was a child. His face beamed at me when he saw a shot I'd just taken come to life, of the joyrides he had just repainted, waiting for another Easter holiday. Two girls on a first date in Blackpool asked me if I would give them a picture to keep – a memory that may sit in a drawer for later in life, to one day be viewed with a loving smile.

That's really what Polaroids do: they make people smile. Besides the nostalgic colours and charm of the slightly out of focus image, it's the fact that they can capture a moment in an instant that makes them so special.

Apart from the opportunity to travel around the country and explore places I wouldn't normally visit, I was saddened by the loneliness sometimes experienced by people who live at the seaside all year. In winter, who wants to go to the pier in Paignton or take a walk through the lanes that run alongside the promenade? The salt takes its toll on the buildings and the streets are stained with a long summer of chip fat and cold beer.

Larger social issues we sometimes choose to ignore are apparent along these landscapes: kids getting stoned, homeless and less fortunate people enjoying the seafront while tourists have gone back to their cozy lives, saving for the next visit to the B&B with another girl. Functional accommodation, 'No Vacancy' signs plastered across the window or doorway. Broken wardrobes, bedside tables and lamps overflowing from skips. Just one curtain pulled across a window as condensation runs down the glass.

Putting all that aside, beachfronts have served as holiday venues and provided good times over the centuries. As a photographer, I love being able to wander around and watch people in this environment, to see how they interact in places designed to be fun. I hope you too smile when looking through these pictures and reflect on your own memories of holidays on the UK's wonderful seaside resorts.

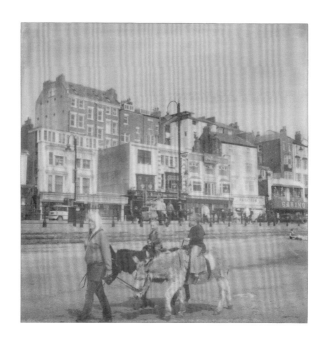

Scarborough, North Yorkshire

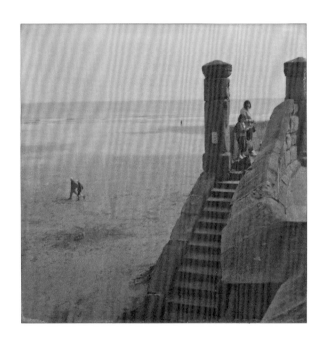

Scarborough, North Yorkshire

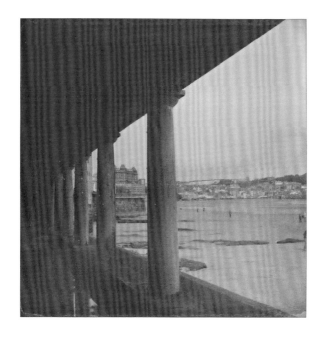

Scarborough, North Yorkshire

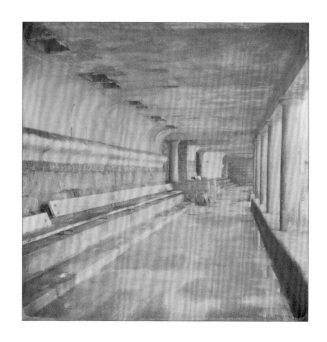

Scarborough, North Yorkshire

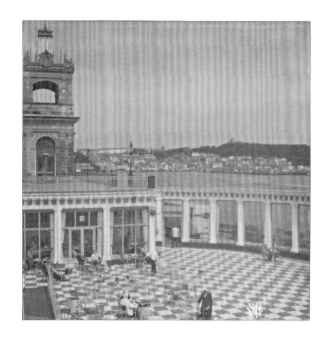

Scarborough, North Yorkshire

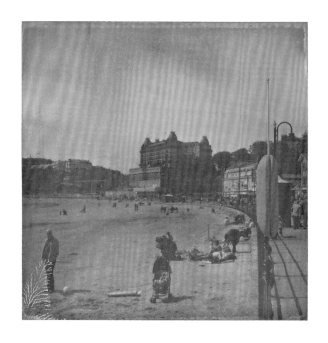

Scarborough, North Yorkshire

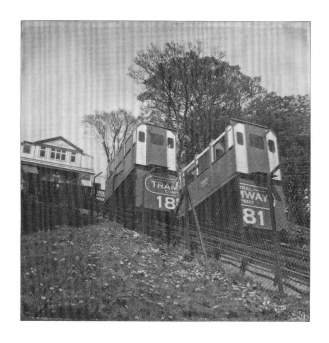

Scarborough, North Yorkshire

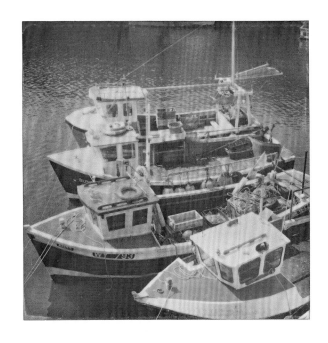

Scarborough, North Yorkshire

Scarborough, North Yorkshire

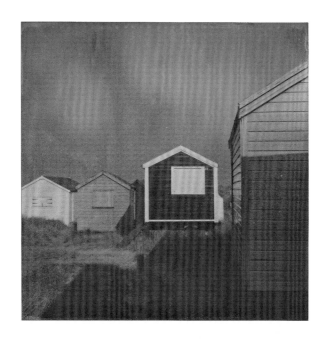

Hunstanton, Norfolk

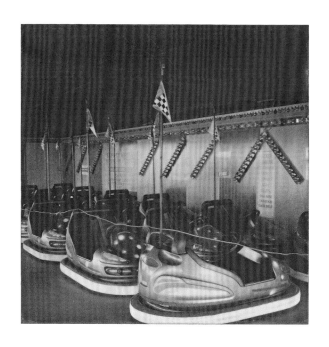

Hunstanton, Norfolk

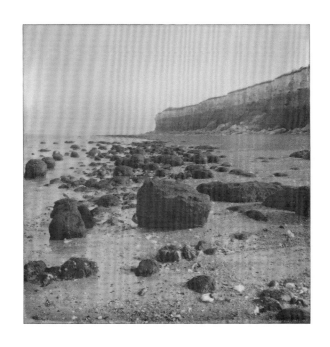

Hunstanton, Norfolk

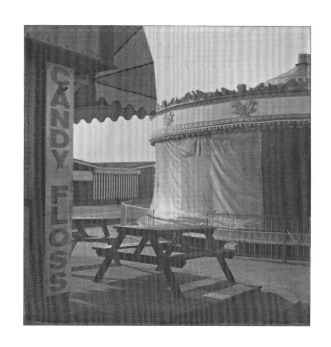

Hunstanton, Norfolk

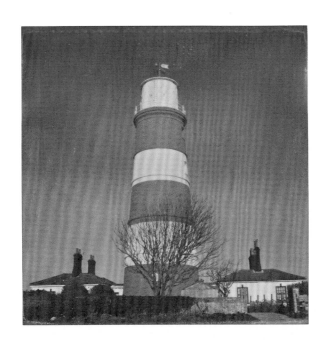

En route to Cromer, Norfolk

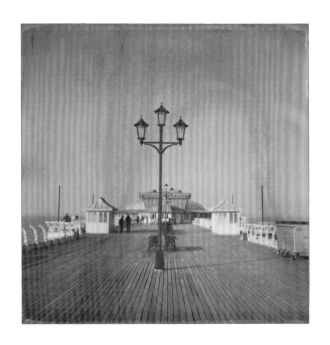

Cromer, Norfolk

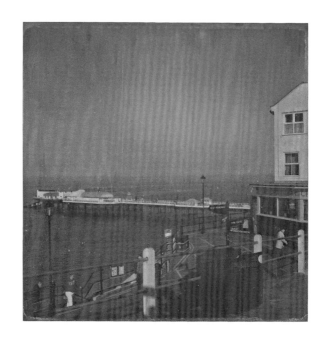

Cromer, Norfolk

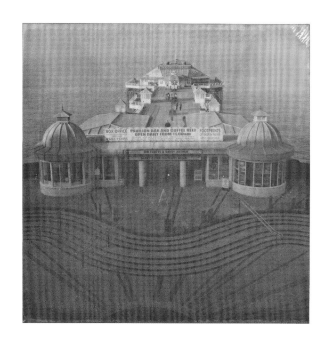

Cromer, Norfolk

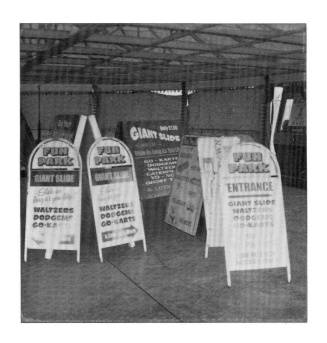

Hemsby, Norfolk

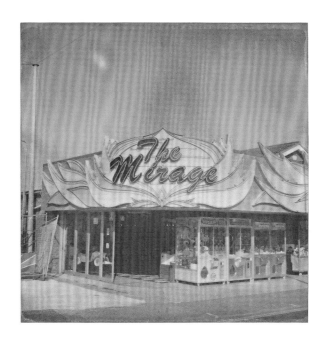

Hemsby, Norfolk

Hemsby, Norfolk

Hemsby, Norfolk

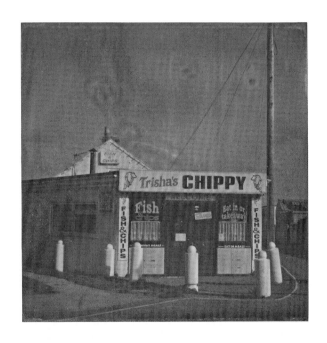

North of Great Yarmouth, Norfolk

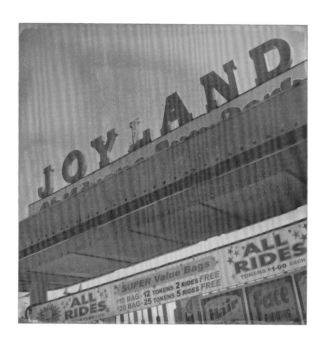

Great Yarmouth, Norfolk

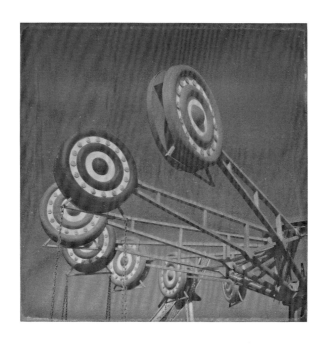

Great Yarmouth, Norfolk

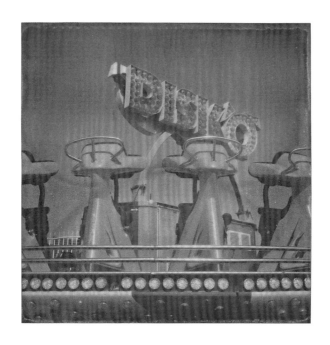

Great Yarmouth, Norfolk

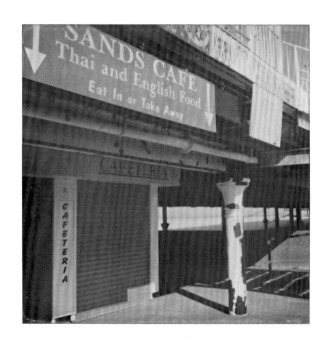

Great Yarmouth, Norfolk

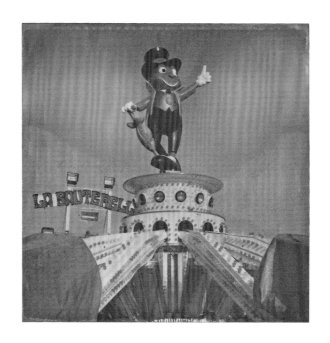

Great Yarmouth, Norfolk

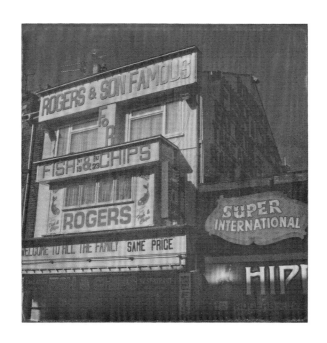

Great Yarmouth, Norfolk

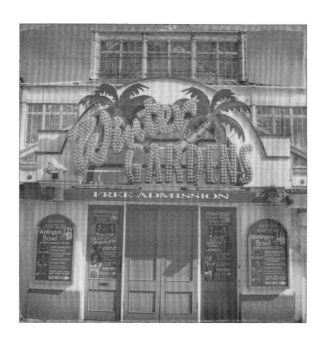

Great Yarmouth, Norfolk

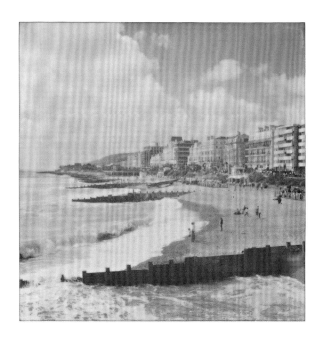

Eastbourne, East Sussex

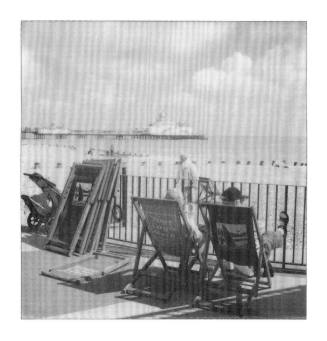

Eastbourne, East Sussex

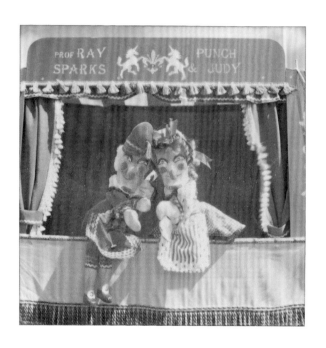

Eastbourne, East Sussex

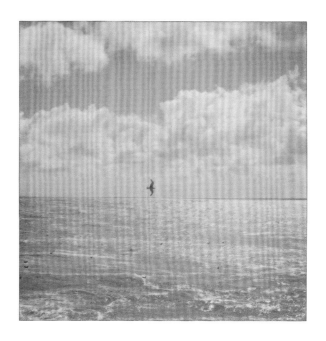

Eastbourne, East Sussex

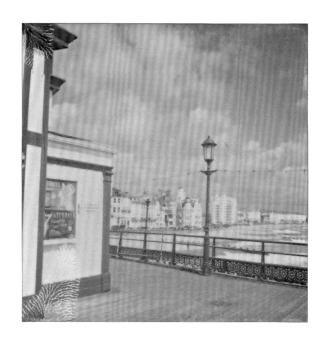

Eastbourne, East Sussex

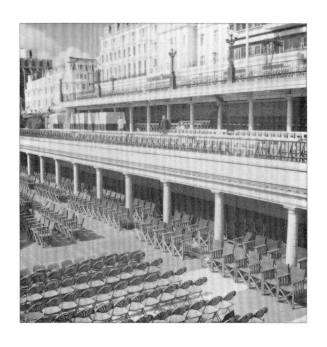

Eastbourne, East Sussex

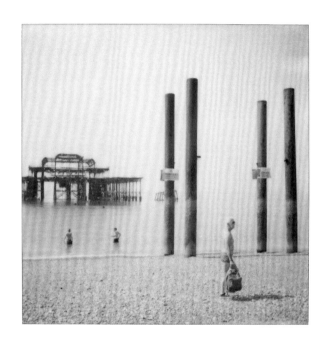

Brighton, East Sussex

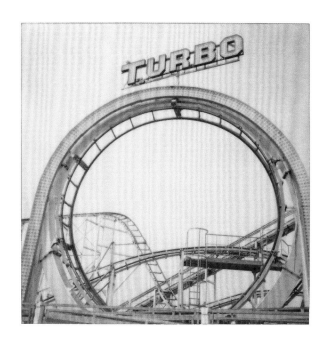

Brighton, East Sussex

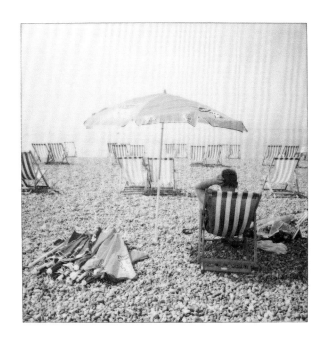

Brighton, East Sussex

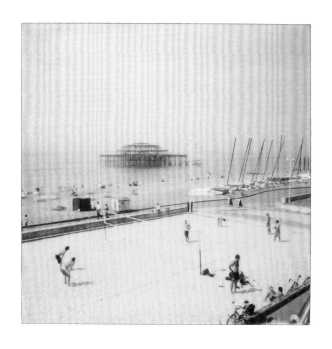

Brighton, East Sussex

Brighton, East Sussex

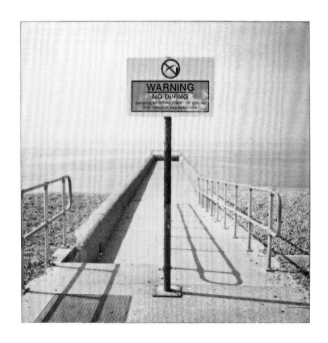

Brighton, East Sussex

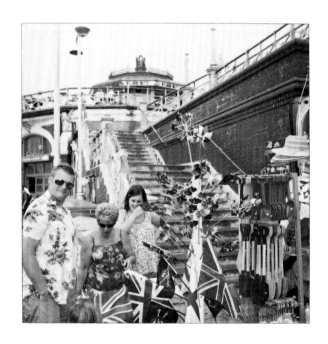

Brighton, East Sussex

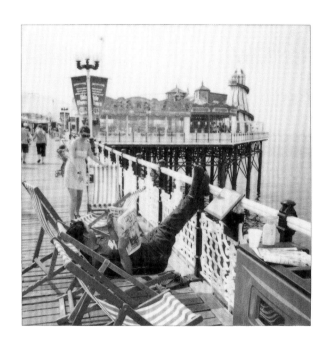

Brighton, East Sussex

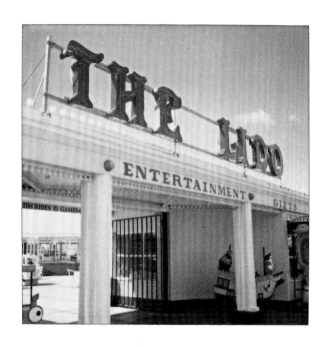

Worthing, West Sussex

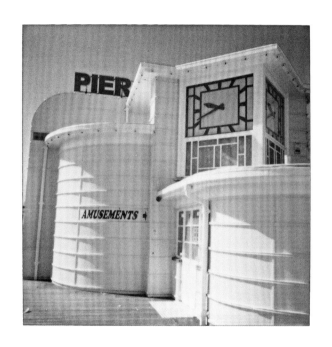

Worthing, West Sussex

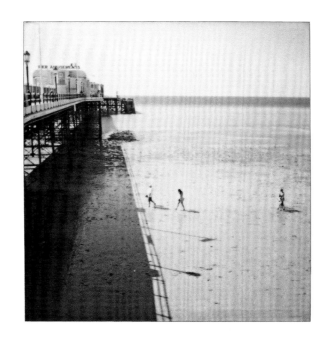

Worthing, West Sussex

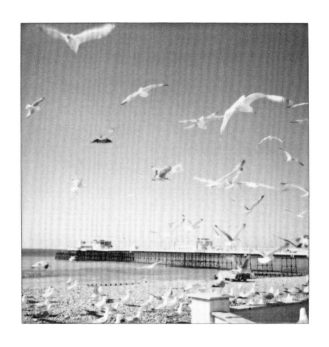

Worthing, West Sussex

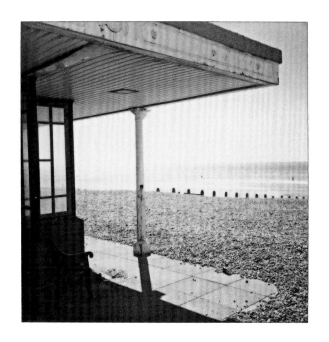

Worthing, West Sussex

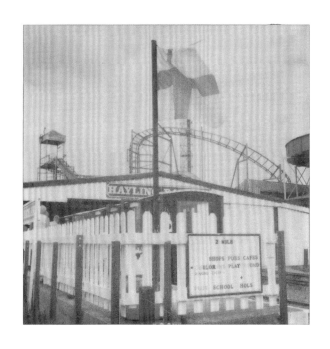

Hayling Island, Hampshire

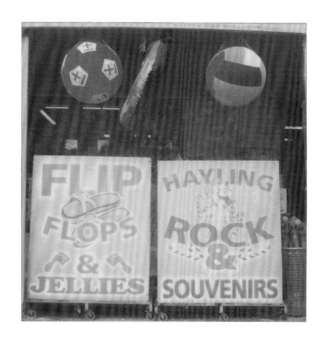

Hayling Island, Hampshire

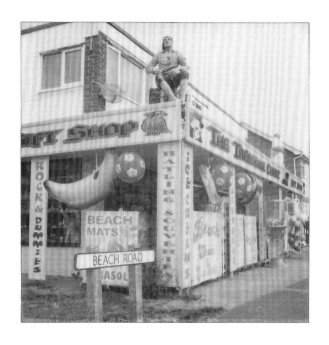

Hayling Island, Hampshire

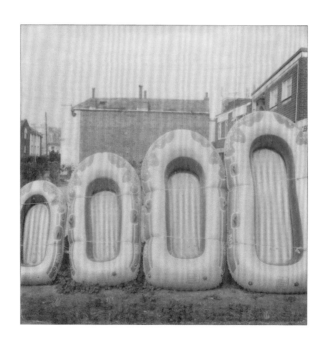

Hayling Island, Hampshire

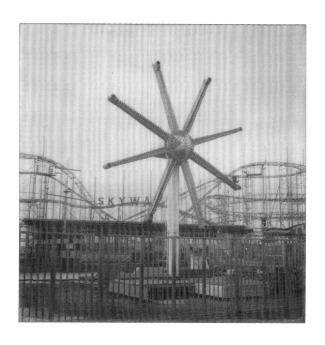

Southsea, Hampshire

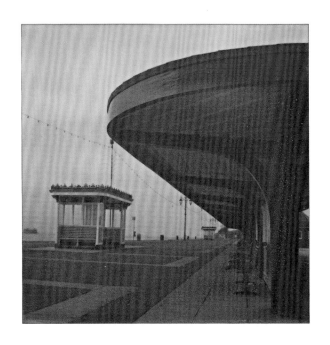

Southsea, Hampshire

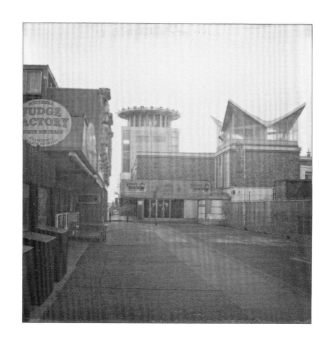

Southsea, Hampshire

Southsea, Hampshire

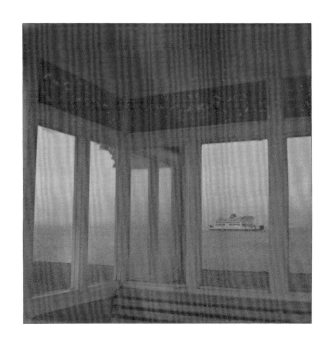

Southsea, Hampshire

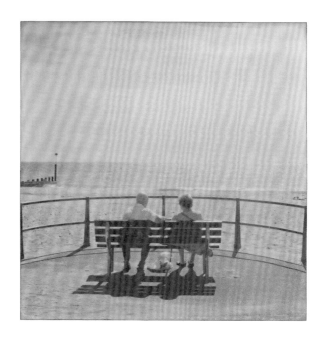

Bournemouth, Dorset

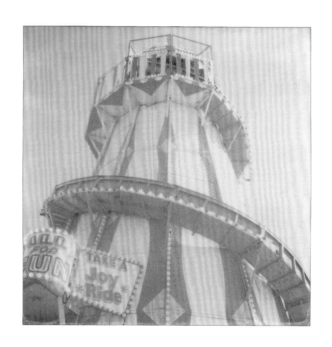

Bournemouth, Dorset

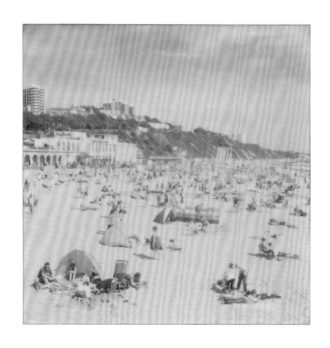

Bournemouth, Dorset

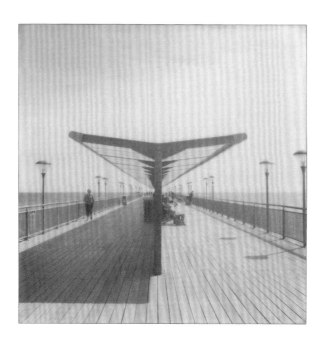

Bournemouth, Dorset

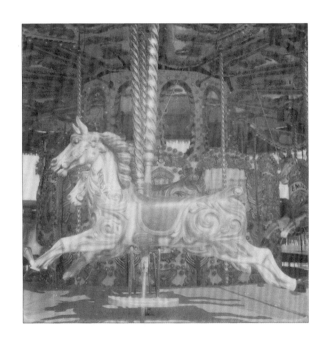

Bournemouth, Dorset

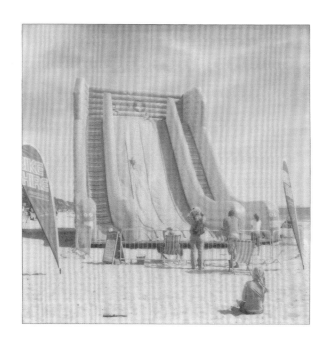

Bournemouth, Dorset

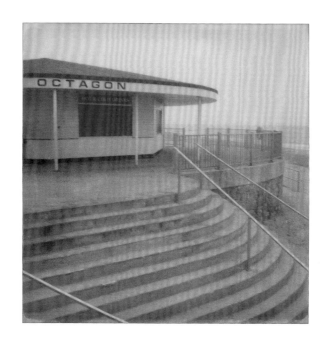

Exmouth, Devon

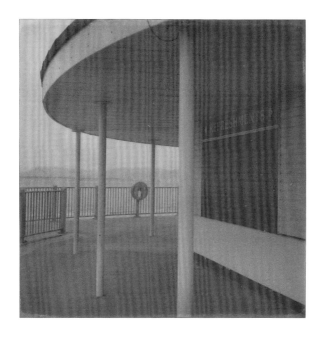

Exmouth, Devon

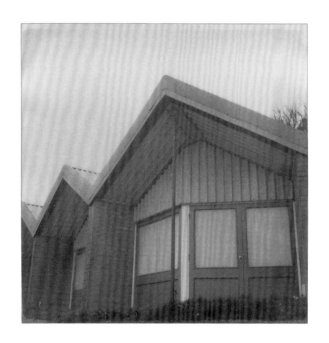

Exmouth, Devon

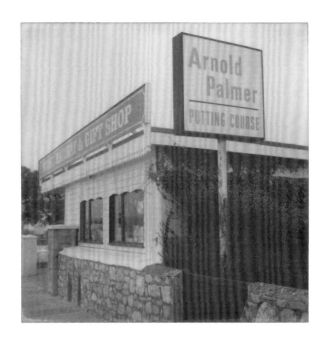

Exmouth, Devon

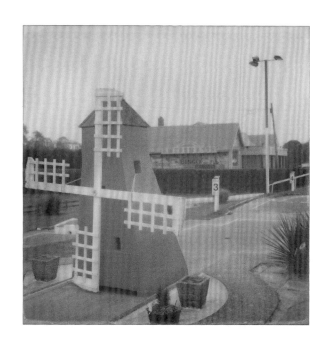

Exmouth, Devon

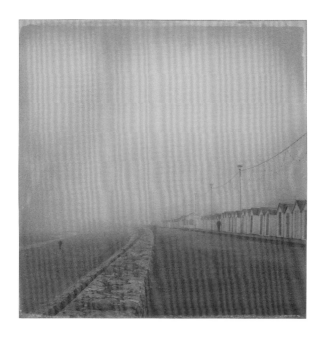

Torquay, Devon

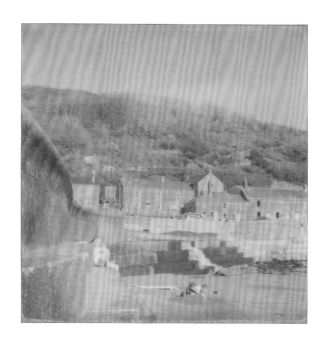

East Portholland, Cornwall

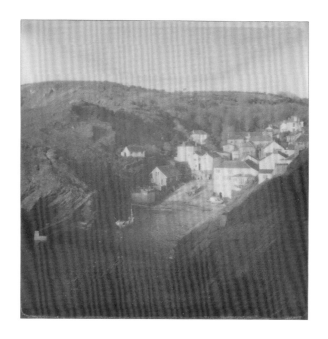

Portloe, Cornwall

Tregenna Castle, Cornwall

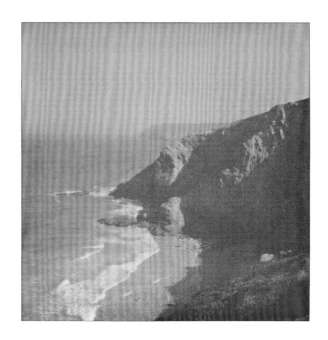

Flat rocks near Porthtowan, Cornwall

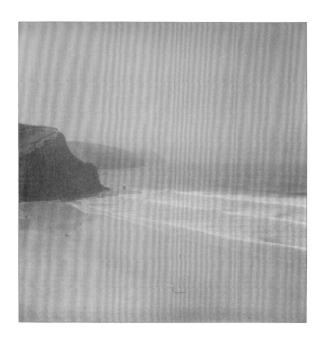

Porthtowan, Cornwall

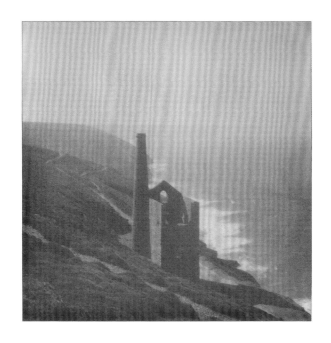

Wheal Coates, Cornwall

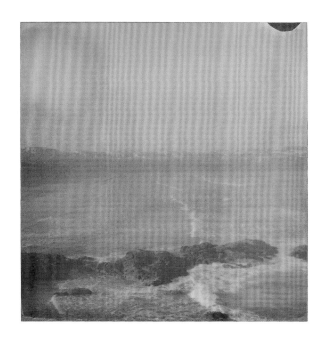

Fistral Beach, Cornwall

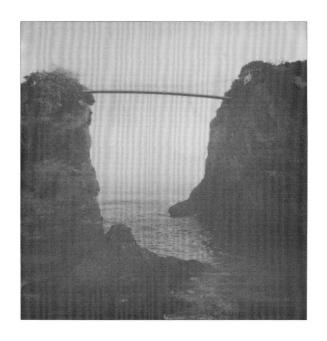

Newquay, Cornwall

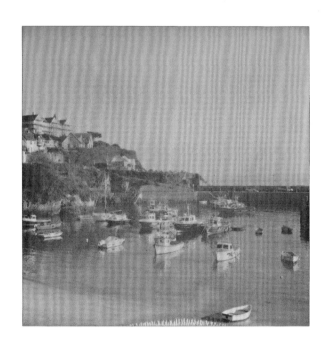

Newquay Harbour, Cornwall

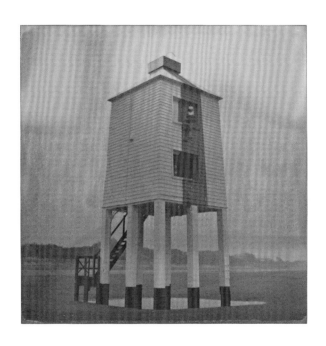

Burnham-on-Sea, Somerset

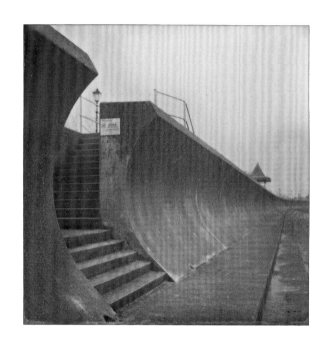

Burnham-on-Sea, Somerset

Blackpool, Lancashire

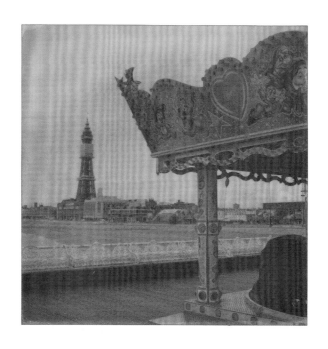

Blackpool, Lancashire

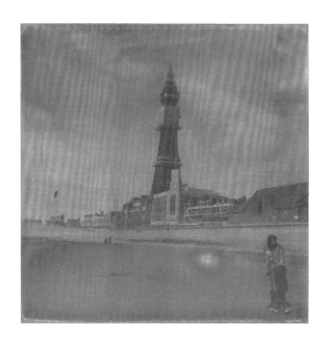

Blackpool, Lancashire

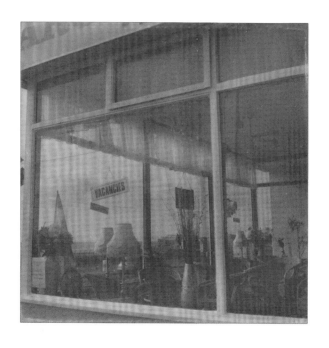

Blackpool, Lancashire

Blackpool, Lancashire

Blackpool, Lancashire

Blackpool, Lancashire

For Katie and Elsa with love x

Front cover: Worthing, West Sussex
Prestel, a member of Verlagsgruppe Random House GmbH

Prestel Verlag
Neumarkter Strasse 28
81673 Munich
Tel +49 (0)89 4136-0
Fax +49 (0)89 4136-2335

www.prestel.de

Prestel Publishing Ltd.
4 Bloomsbury Place
London WC1A 2QA
Tel +44 (0) 20 7323-5004
Fax +44 (0) 20 7636-8004

www.prestel.com

Prestel Publishing
900 Broadway, Suite 603
New York, N.Y. 10003
Tel +1 (212) 995-2720
Fax +1 (212) 995-2733

Library of Congress Control Number: 2012952515

British Library Cataloguing-in-Publication Data:
a catalogue record for this book is available from
the British Library. The Deutsche Bibliothek holds
a record of this publication in the Deutsche
Nationalbibliografie; detailed bibliographical data
can be found under: http://dnb.d-nb.de

Prestel books are available worldwide.
Please contact your nearest bookseller or one
of the above addresses for information concerning
your local distributor.

Editorial direction: Ali Gitlow
Editorial assistance: Katie Balcombe, Eve Dawoud
Design and layout: Damien Poulain
Production: Friederike Schirge
Origination: Reproline Mediateam, Munich
Printing and binding: Firmengruppe Appl, Wemding

Verlagsgruppe Random House FSC-DEU-010
The FSC-certified paper Profisilk has been supplied
by Igepa.

Printed in Germany
ISBN 978-3-7913-4730-1